RENOIR

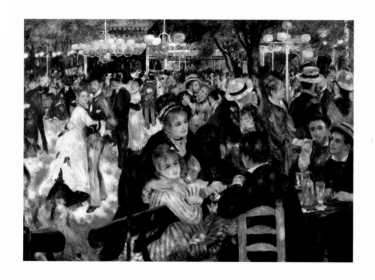

FAWCETT COLUMBINE · NEW YORK

A Fawcett Columbine Book
Published by Ballantine Books

First published in Great Britain in 1991 by
PAVILION BOOKS LIMITED
196 Shaftesbury Avenue, London WC2H 8JL

Cover design by Richard Aquan

ISBN: 0-449-90583-7

Printed and bound in Singapore by Imago Publishing Limited
First American Edition: October 1991

10 9 8 7 6 5 4 3 2 1

FOREWORD

*A*uguste Renoir (1841–1919) began work as a painter in a porcelain factory where he gained experience with the light, fresh colors that were to distinguish his artwork. Initially his paintings of the 1870s typified the mainstream of the Impressionist Movement, as seen in such images as *The Fisherman*. Always the least doctrinaire of the group, however, he also applied Impressionist techniques to nudes and portraits as well as the usual landscapes and still lifes. There is a cheerful glow suffusing most of his work, which also sets him apart, and the buoyant mood of the *Belle Epoque* is nowhere more warmly celebrated than in Parisian scenes such as *Le Moulin de la Galette*.

Renoir was always fascinated by the old masters and, following visits to Italy in the 1880s, he turned away from the luminosity of Impressionism to a greater sense of solidity. His style became more refined, a transition at work in the 1883 *Umbrellas*. After a period of stylistic experimentation he returned in the 1890s to his natural warmth and serenity, as in his enchanting child portraits, notably of his son Jean with his maid, and in numerous studies of nudes. These timeless representations of lush landscapes and healthy, plump young bodies represent the creative fulfillment of one who was, both in his character and his art, the most relaxed and approachable of all the Impressionist artists.

FAWCETT COLUMBINE · NEW YORK

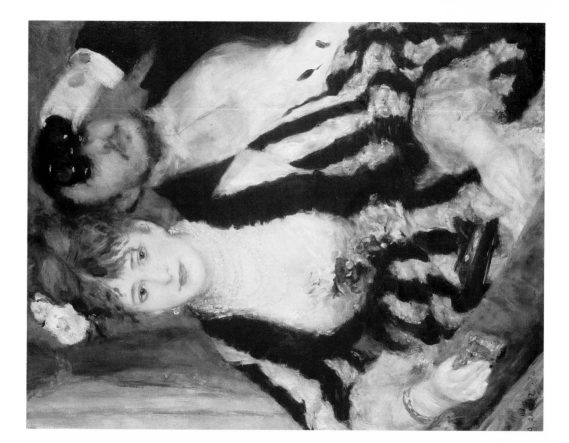

PIERRE AUGUSTE RENOIR (1841-1919)
The Theatre Box
COURTAULD INSTITUTE GALLERIES, UNIVERSITY OF LONDON/
BRIDGEMAN ART LIBRARY, LONDON

FAWCETT COLUMBINE · NEW YORK

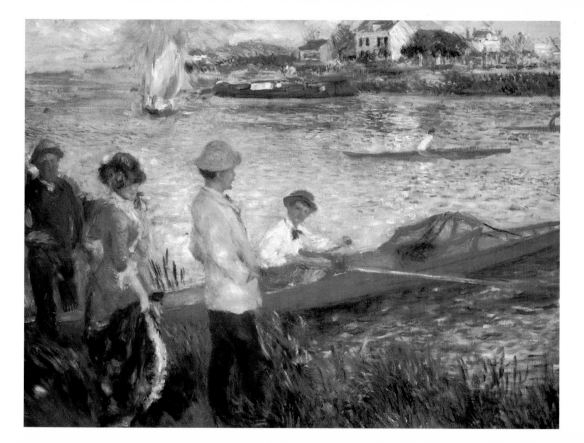

PIERRE AUGUSTE RENOIR (1841-1919)
Oarsmen at Chatou
NATIONAL GALLERY OF ART, WASHINGTON D.C./
BRIDGEMAN ART LIBRARY, LONDON

FAWCETT COLUMBINE · NEW YORK

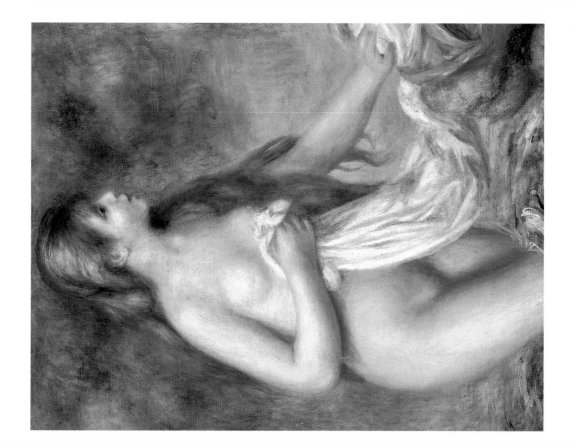

PIERRE AUGUSTE RENOIR (1841-1919)
Bather with Long Hair
MUSÉE D'ORSAY, PARIS/BRIDGEMAN ART LIBRARY, LONDON

FAWCETT COLUMBINE · NEW YORK

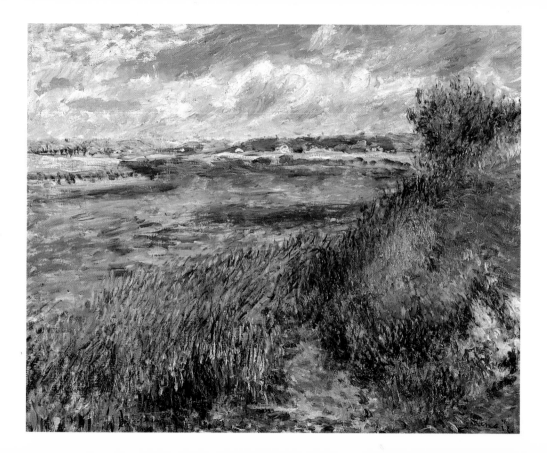

PIERRE AUGUSTE RENOIR (1841-1919)
On the Banks of the Seine
MUSÉE D'ORSAY, PARIS/GIRAUDON, PARIS/
BRIDGEMAN ART LIBRARY, LONDON

FAWCETT COLUMBINE · NEW YORK

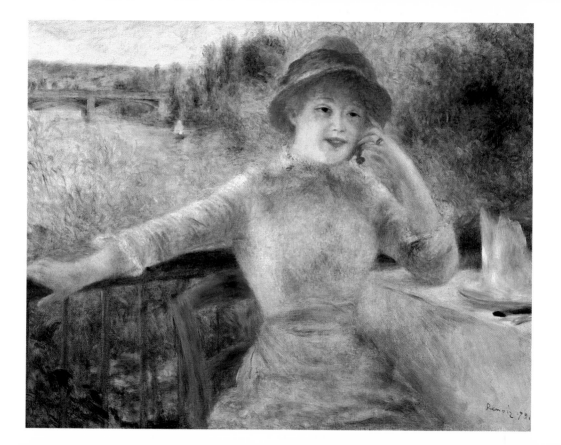

PIERRE AUGUSTE RENOIR (1841-1919)
Alphonsine Fournaise at the Grenouillère
MUSÉE D'ORSAY, PARIS/BRIDGEMAN ART LIBRARY, LONDON

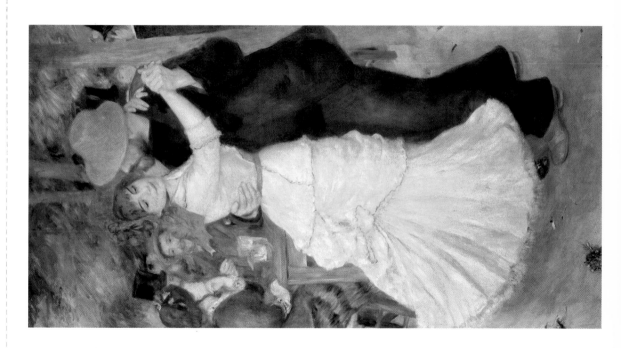

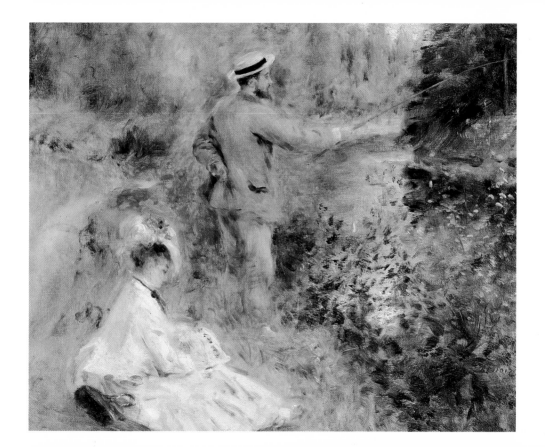

FAWCETT COLUMBINE · NEW YORK

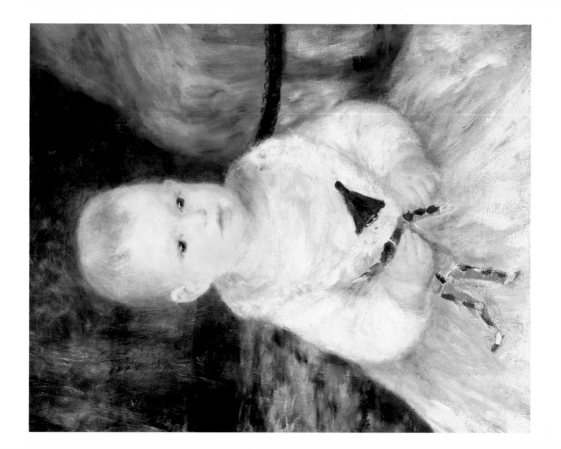

FAWCETT COLUMBINE · NEW YORK

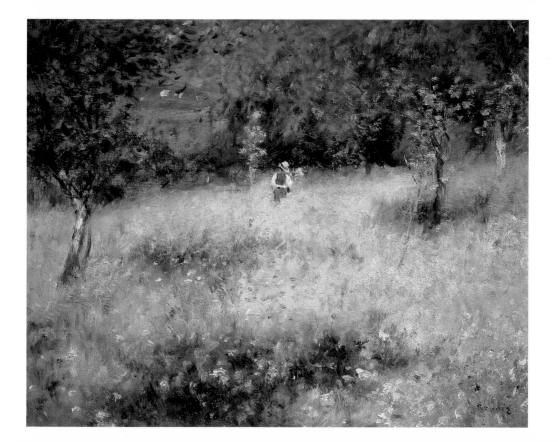

FAWCETT COLUMBINE · NEW YORK

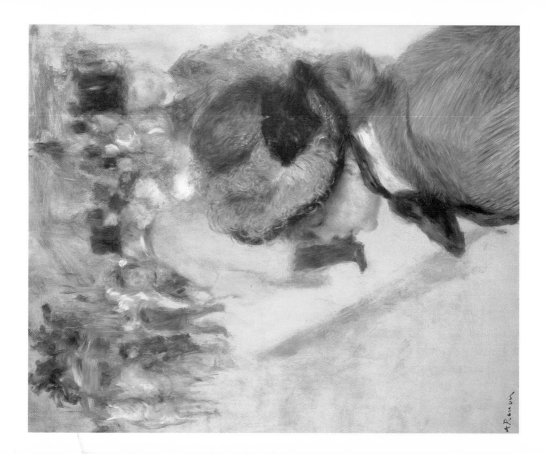

PIERRE AUGUSTE RENOIR (1841-1919)
Place Clichy
PRIVATE COLLECTION/BRIDGEMAN ART LIBRARY, LONDON

FAWCETT COLUMBINE · NEW YORK

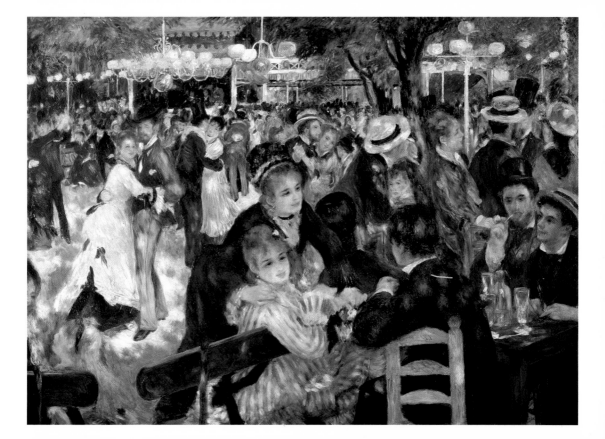

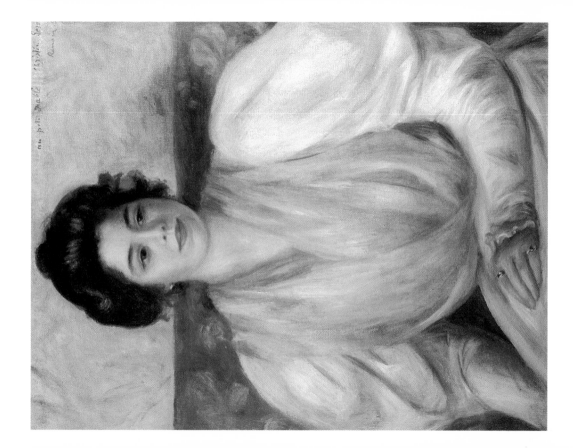

FAWCETT COLUMBINE · NEW YORK

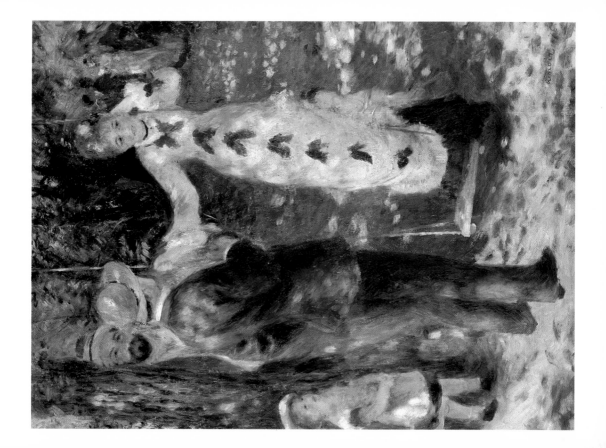

PIERRE AUGUSTE RENOIR (1841-1919)
The Swing
MUSÉE D'ORSAY, PARIS/GIRAUDON, PARIS/
BRIDGEMAN ART LIBRARY, LONDON

FAWCETT COLUMBINE · NEW YORK

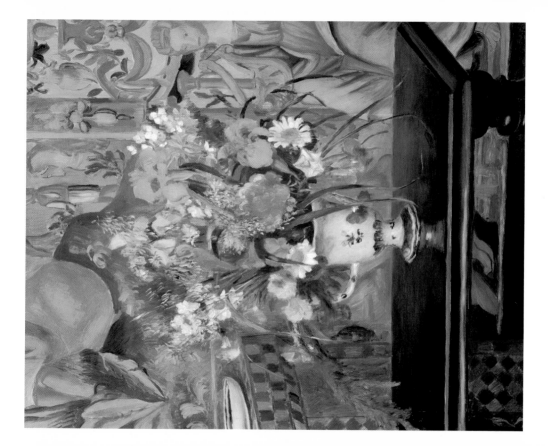

PIERRE AUGUSTE RENOIR (1841-1919)
Flowers in a Vase
PRIVATE COLLECTION/BRIDGEMAN ART LIBRARY, LONDON

FAWCETT COLUMBINE · NEW YORK

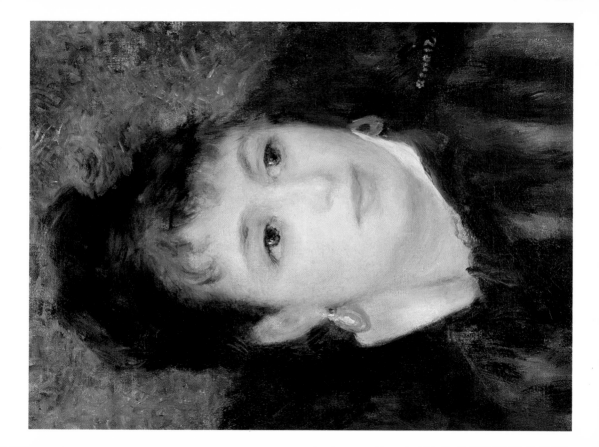

PIERRE AUGUSTE RENOIR (1841-1919)
Woman with a Rose
CHRISTIE'S, LONDON/BRIDGEMAN ART LIBRARY, LONDON

FAWCETT COLUMBINE · NEW YORK

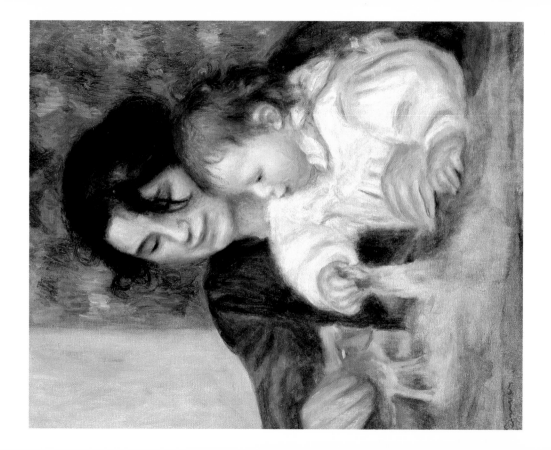

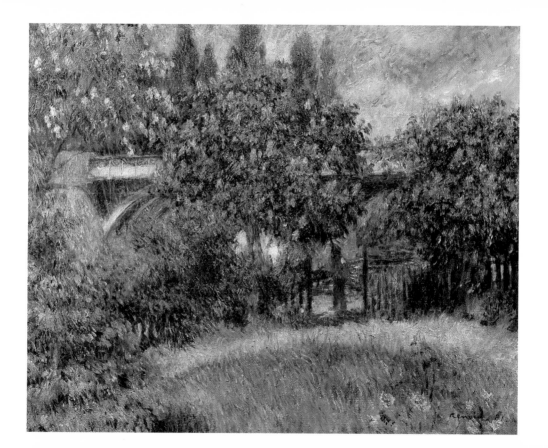

PIERRE AUGUSTE RENOIR (1841-1919)
Railway Bridge at Chatou
MUSÉE D'ORSAY, PARIS/GIRAUDON, PARIS/
BRIDGEMAN ART LIBRARY, LONDON

FAWCETT COLUMBINE · NEW YORK

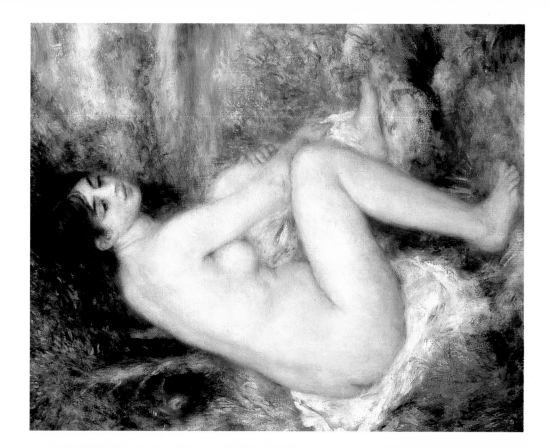

FAWCETT COLUMBINE · NEW YORK

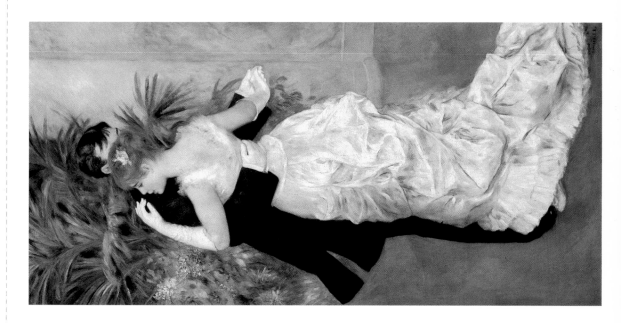

PIERRE AUGUSTE RENOIR (1841-1919)
Dancing in the Town
MUSÉE D'ORSAY, PARIS/BRIDGEMAN ART LIBRARY, LONDON

FAWCETT COLUMBINE · NEW YORK

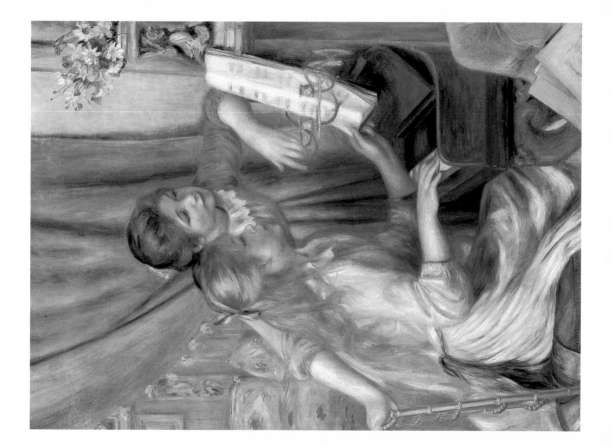

PIERRE AUGUSTE RENOIR (1841-1919)
Young Girls at the Piano
LOUVRE, PARIS/BRIDGEMAN ART LIBRARY, LONDON

FAWCETT COLUMBINE · NEW YORK

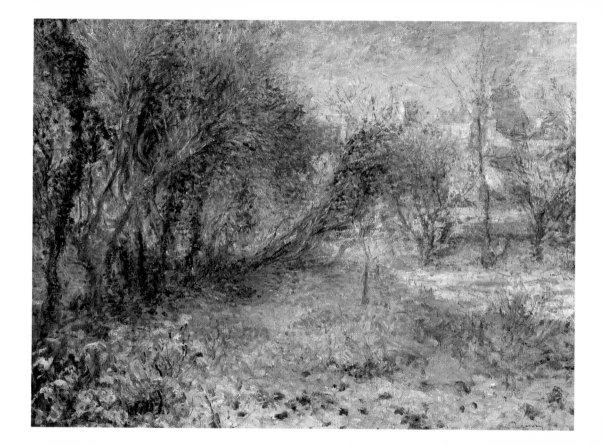

PIERRE AUGUSTE RENOIR (1841-1919)
Countryside under Snow
MUSÉE D'ORSAY, PARIS/GIRAUDON, PARIS/
BRIDGEMAN ART LIBRARY, LONDON

FAWCETT COLUMBINE · NEW YORK

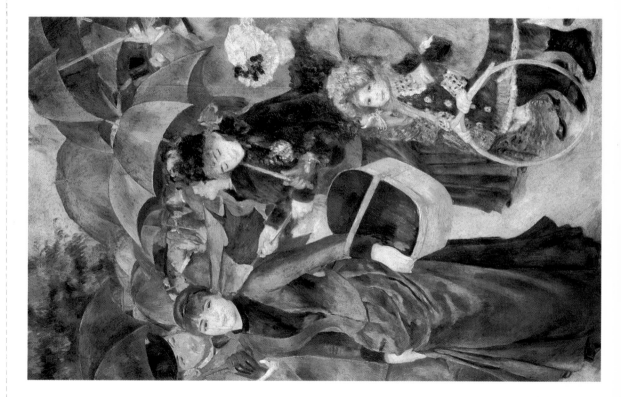

FAWCETT COLUMBINE · NEW YORK

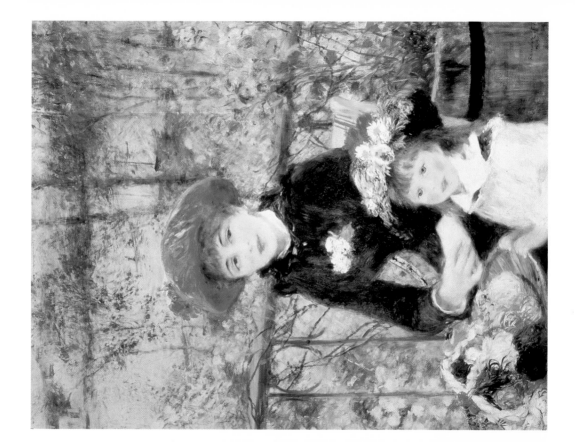

PIERRE AUGUSTE RENOIR (1841-1919)
On the Terrace
ART INSTITUTE OF CHICAGO/BRIDGEMAN ART LIBRARY, LONDON

FAWCETT COLUMBINE · NEW YORK

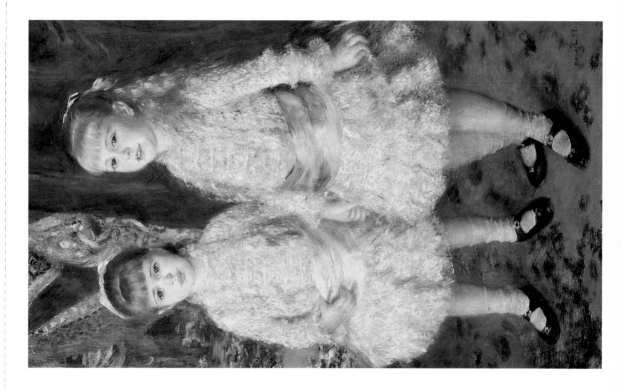

PIERRE AUGUSTE RENOIR (1841-1919)
Rose and Blue
MUSEU DE ART DE SAO PAULO, BRAZIL/GIRAUDON, PARIS/
BRIDGEMAN ART LIBRARY, LONDON

FAWCETT COLUMBINE · NEW YORK

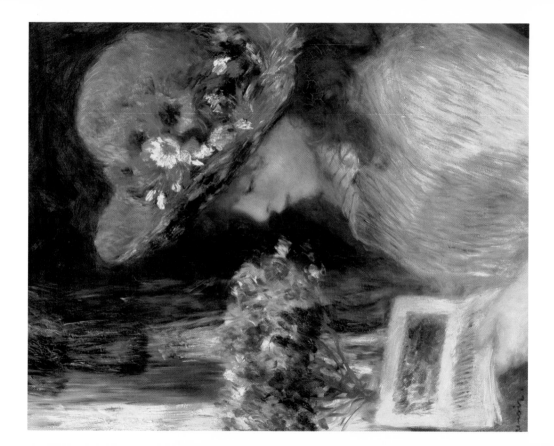

PIERRE AUGUSTE RENOIR (1841-1919)
Girl Reading
STADTISCHES KUNSTHAUS, FRANKFURT/
BRIDGEMAN ART LIBRARY, LONDON

FAWCETT COLUMBINE · NEW YORK

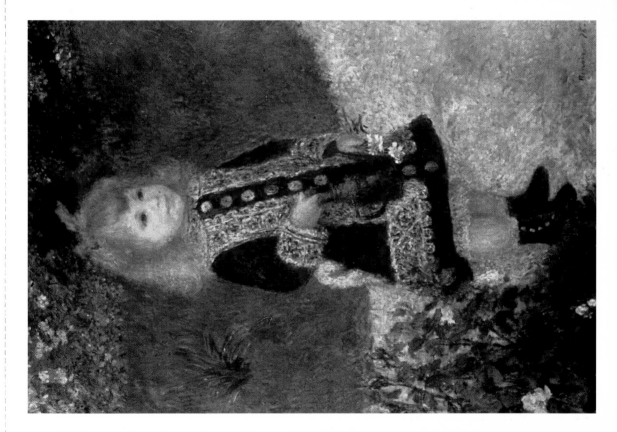

PIERRE AUGUSTE RENOIR (1841-1919)
A Girl with a Watering Can
NATIONAL GALLERY OF ART, WASHINGTON D.C./
BRIDGEMAN ART LIBRARY, LONDON

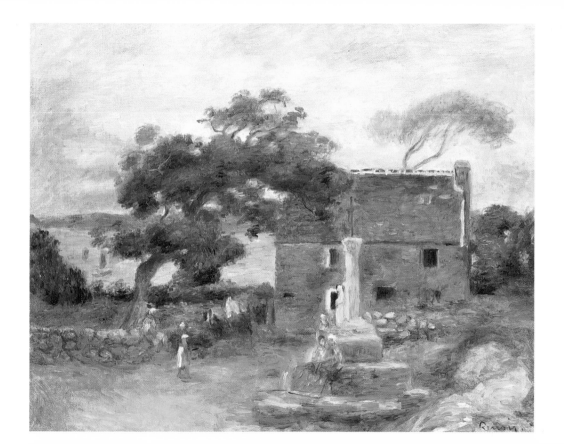

PIERRE AUGUSTE RENOIR (1841-1919)
The Farmhouse at Cagnes
CHRISTIE'S, LONDON/BRIDGEMAN ART LIBRARY, LONDON

FAWCETT COLUMBINE · NEW YORK

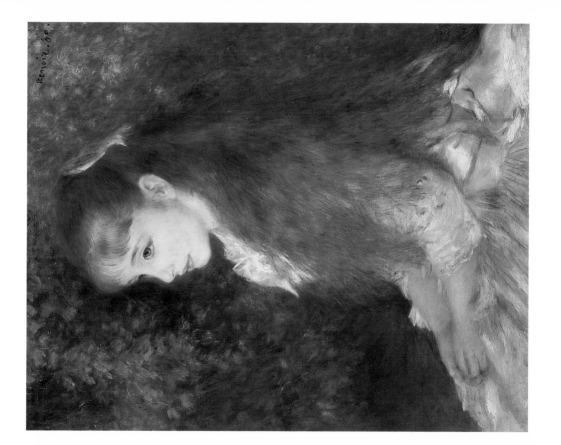

PIERRE AUGUSTE RENOIR (1841-1919)
Portrait of a Young Girl
BUHRLE FOUNDATION, ZURICH/BRIDGEMAN ART LIBRARY, LONDON

FAWCETT COLUMBINE · NEW YORK

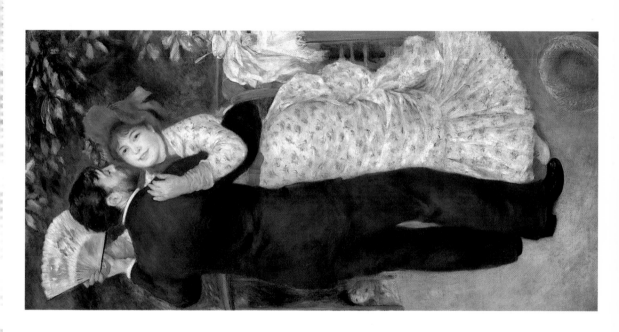

PIERRE AUGUSTE RENOIR (1841-1919)
Dancing in the Country
MUSÉE D'ORSAY, PARIS/GIRAUDON, PARIS/
BRIDGEMAN ART LIBRARY, LONDON

FAWCETT COLUMBINE · NEW YORK